£6.

Ruskin's
drawings
in the
Ashmolean
Museum

Ruskin's drawings
in the
Ashmolean
Museum

Nicholas Penny

Series sponsored by

Fine Art Auctioneers

Ashmolean Museum Oxford
1988

Text and illustrations © Ashmolean Museum, Oxford 1988
All rights reserved
ISBN 0-907849-74-1 (paperback)

Titles in this series include:
Worcester porcelain
Italian maiolica

British Library Cataloguing in Publication Data
Ashmolean Museum
 Ruskin's drawings in the Ashmolean Museum
 1. English drawings. Ruskin, John, 1819–1900
 I. Title II. Penny, Nicholas, *1949–*
 III. Ruskin, John, *1819–1900*
 741.942

Cover illustration: Study of kingfisher, no. 14

Designed by Cole design unit, Reading
Set in Versailles by Meridian Phototypesetting Limited
Printed and bound in Great Britain by
Jolly & Barber Limited, Rugby

For Caroline

Introduction

John Ruskin's masterpieces, *Modern Painters, The Seven Lamps of Architecture* and *The Stones of Venice,* which appeared in the 1840s and 1850s, changed the ways in which his readers thought about, indeed saw, art, architecture and the natural world. Modern readers, who often know Ruskin only from anthologies, are unaware that this was achieved not only by his dazzling prose but by his illustrations. These were often made after Ruskin's own drawings, and they were carefully supervised by him. He selected the various methods of reproduction and sometimes participated in making the plates. He devised entirely new and exciting visual ways of presenting his ideas, whether about the structure of glaciers or the evolution of gothic mouldings. Some of the drawings he made or adapted for this purpose are reproduced here – in colour, of course, as they never could have been in his lifetime.

Ruskin was elected as the first Slade Professor of Art at Oxford University in 1869. Re-elected in 1873 and 1876, he resigned at the end of 1878, but was again elected in 1883. He devoted as much energy and ingenuity to devising appropriate visual aids for his lectures as he had to making illustrations for his books. Some pictures were placed on the wall, some on tables. Some were hung face to the wall to tantalize, or were carried in under covers by a servant at a crucial moment. He even demonstrated some points by drawing on top of the glass by which watercolours were covered. What, one wonders, would he have done with slide-projectors! Despite the enlargements which he had made, there must always have been a problem of visibility, especially

since the lectures were given to huge audiences: consequently classes had to be held at the close of each lecture for more careful examination of the ilustrations. These sometimes included material made for his earlier books.

It was these classes that helped give Ruskin the idea of adding to the watercolours by Turner, which he had earlier donated to the University Galleries, a large collection of drawings by himself and others, together with casts, prints and photographs. He gave the collection formally to the University in 1875. He endowed a Drawing Mastership, made catalogues, designed frames for the drawings and mahogany cabinets to store them. Works of art were arranged in four series. The Educational and Rudimentary series were intended to provide examples for practical instruction (the latter being designed for artisans in the 'general class'); the Standard series was a collection of touchstones for the criticism of art; the Reference series consisted of miscellaneous material to be consulted in connection with his lectures. The complex system was never fully worked out – a fate shared with all other ambitious schemes of his. The University, for both good and bad reasons, was not as enthusiastic as Ruskin hoped it would be: even those who most revered Ruskin were aware of how cranky and whimsical he could be, especially in his practical endeavours. Ruskin grew disillusioned and even tried to withdraw some of his gifts. The enterprise was a failure both as a programme for the critical and practical education of gentlemen and as a night school for artisans (today's flourishing Ruskin School is conducted along very different lines without reference to Ruskin's

8

intentions). However, the drawings continued to be cared for in the Ashmolean Museum (as the University Galleries became) and there is probably now more interest in them than ever before.

Almost all the drawings illustrated and discussed in this book are from the collection which Ruskin gave to the University and an attempt has been made to indicate the educational value that he attached to them and the (often different) purpose for which they were made. The titles are, wherever possible, those that he gave to them. They have been arranged thematically to illustrate the chief preoccupations of his life both as an artist and as a writer, with a short introductory text to each group.

The best biography of Ruskin is that by Tim Hilton of which the first volume (*John Ruskin: The Early Years 1819–1859*) was published in 1985 and the second will appear shortly. Paul Walton's *The Drawings of John Ruskin,* Oxford, 1972, provides an admirable introduction to Ruskin's own drawings. Ruskin's books, often in handsome early editions, are easily purchased from second-hand bookshops. Most major libraries possess the Library edition of Ruskin's *Works* in 39 volumes published between 1903 and 1912, edited with awe-inspiring thoroughness by E.T. Cook and Alexander Wedderburn. Volume XXI provides an account of Ruskin's attempt to establish a school in the University Galleries, and catalogues the series of drawings there. A reconstruction of the Rudimentary Series as Ruskin arranged it in 1873 was published by the Royal College of Art in 1984, scrupulously edited by Robert Hewison.

1
The accomplished amateur and the picturesque

Ruskin lived in a period in which some sort of artistic activity, especially in the portable and unmessy medium of watercolour, with landscape as the subject, studied in the healthy outdoors, was widespread among the more affluent sections of society. It was an accomplishment, comparable with playing the piano. (Things have changed: music lessons of course remain something for which the educated upper middle class is generally eager to pay, but drawing masters are seldom now privately employed.) There was often an intimate relationship between the collecting of watercolour drawings and the work of amateurs in this field. The best male practitioners certainly tended to be collectors. There was also a relationship with recreational travel. The modern middle class family holiday originated in this period and its pretext was often the pursuit of picturesque views.

Ruskin, the only child of a talented, cultivated and very prosperous sherry importer who was a keen collector of modern watercolours, was taught to draw by Copley Fielding, one of the leading artists in this medium (and the most fashionable and expensive teacher of the period), and was also encouraged to collect for himself. He exercised his skills chiefly on holiday with his parents – indeed it was the work of Samuel Prout and Turner which prompted their visits to Europe. Three of the drawings here (nos. 1–3) date from Ruskin's Italian and French tour of 1840–41 made on doctor's orders to escape from the severe depression and suspected consumption with which he had been afflicted as an undergraduate at Oxford. They are typical souvenir views but remarkably accomplished and very

disciplined. They reveal how Ruskin first approached architecture as scenery. He was anxious to make a picture out of it and was not yet concerned to investigate its construction or its details.

1
The Capitol from the Forum
34.4 × 49.5 cm

John Ruskin travelled with his parents to Rome for Christmas of 1840 and returned there in the spring of 1841 after a visit to Naples. They were avoiding the English winter – desperately seeking to improve Ruskin's physical and mental health. Drawing (unlike reading) was prescribed as therapy. In his diary Ruskin noted that he had been sketching in the Forum on 3 April. He included this drawing in the Reference Series (as no. 88) of his teaching collection in Oxford but for a purpose he never elucidated. The technique of this and other drawings from this period (nos. 2 and 3) – the careful work in pencil and pen on blue-green or grey paper with watercolour or ink-wash for shadows, and white or yellow body colour for the highlights applied neatly afterwards with a brush – is much influenced by the drawings of David Roberts and to a lesser extent by those of Samuel Prout, both of whom Ruskin knew.

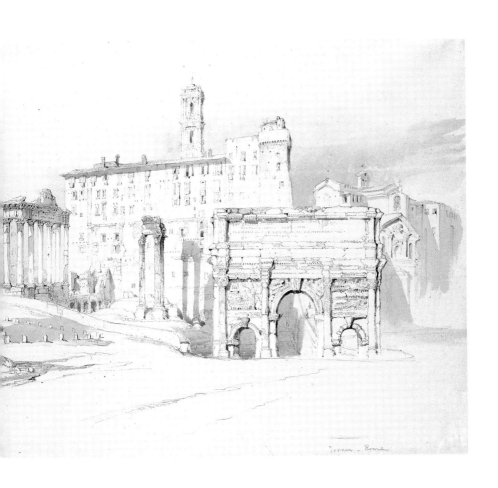

2
Casa Contarini Fasan (and neighbouring palaces on the Grand Canal), Venice
42.7 × 31.6 cm

The Ruskins were in Venice from 6 May to 16 May 1841 and this drawing was probably the sketch on the Grand Canal with which Ruskin expressed some satisfaction in his diary on 14 May. In 1876, while staying in one of the palaces depicted here, Ruskin recalled how Samuel Prout had borrowed this drawing (which is somewhat in his manner) to copy. It was included in the Reference Series (as no. 65) of his collection, and in the catalogue he explained that it and other Venetian studies 'exhibit some architectural characters which are not seen in photographs' – of which he also presented numerous examples – 'and sometimes present features of the buildings which are now destroyed, or soon likely to be so'. The way that the composition expires towards the right of the sheet is typical.

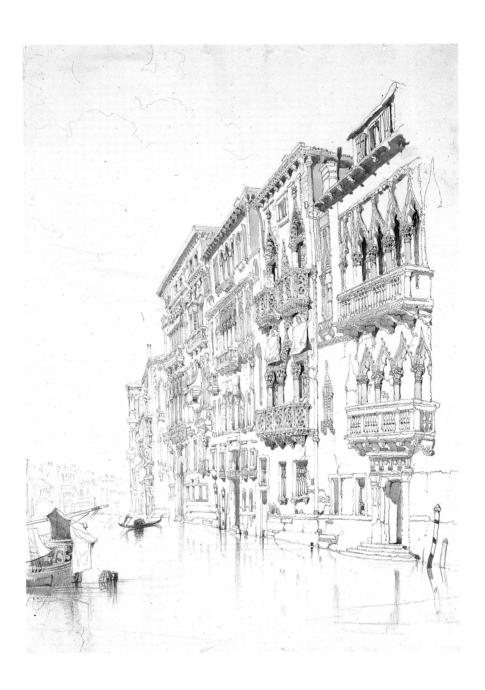

3
The market place (Piazza delle Erbe), Verona
34 × 48.5 cm (detail reproduced in colour)

On 19 May 1841 Ruskin noted in his diary that he had sketched all day under a huge umbrella (no doubt like those in the picture) beside a cheese stall in the great square at Verona. He included this drawing in the Reference Series (as no. 82) of his collection, together with other views of Verona made by him and others at different dates. They were assembled by him in the first place for an exhibition to illustrate a lecture on Verona which he gave at the Royal Institution on 4 February 1870.

The stillness of the scene in this and the other drawings of this period – especially the canal view (no. 2) where the water has a glassy stillness – is enhanced by the depopulation which is due to the artist's lack of ability to draw human beings (or indeed any mobile subject matter) with confidence.

Ruskin is as attracted by crumbling Roman architecture and encrusted Renaissance palaces, both of which he came to detest, as he is by the north Italian Gothic which he later revered. An openness to a wide variety of picturesque effects and historic periods is also evident in the articles that he had begun to publish on 'The Poetry of Architecture' before he came up to Oxford.

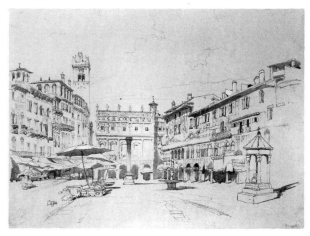

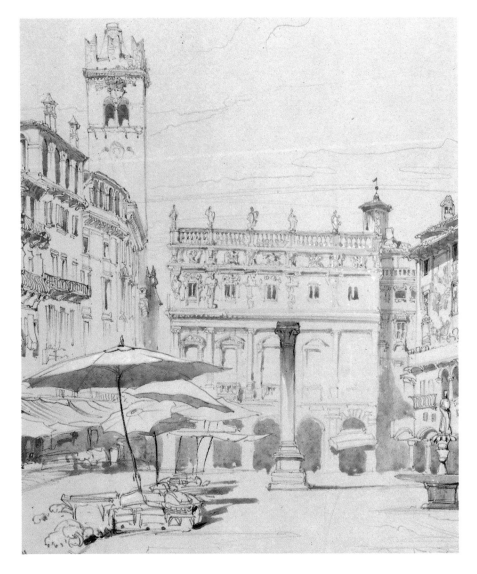

2
The inspiration and interpretation of Turner

Ruskin had loved Turner's art since the early 1830s but his obsessive passion for it developed in the early 1840s: his earliest imitation of Turner's watercolour style was made on his return to England in the summer of 1841. In the winter of 1841 he enrolled as a pupil of J.D. Harding, a brilliant draughtsman and a polemical author who greatly admired Turner. Ruskin's defence of Turner's art, the first volume of *Modern Painters,* was published, and widely acclaimed, in 1843. In it he argued eloquently that Turner had looked at the structure of mountains and clouds, at the colour of sky and water, at the forms of trees as no artist ever had done before. Ruskin's own work changed character. Investigations of vegetable growth and mineral evolution and records of skies replace picturesque compositions, and an earnest dedication to truth replaces the tourist's interest in scenery.

Although drawing was esteemed as a social accomplishment, this did not mean that it was valued as a part of serious education. Yet Turner, Ruskin believed, possessed a genius comparable to that of a great poet, scientist or religious thinker, and the failure to realise this was a matter of desperate concern. Ruskin even hoped that he would be able to make his own University venerate Turner.

The campaign to purchase, for the newly built University Galleries in Oxford, the superb collection of drawings by Michelangelo and Raphael which had been formed by Sir Thomas Lawrence, had opened in the year before the first volume of *Modern Painters* appeared. It was surely because these drawings were acquired for Oxford that Ruskin decided to present to the University the series of drawings of 'The

Rivers of France' by Turner which he regarded as one of Turner's greatest achievements. The original theme of *Modern Painters* had been to demonstrate that there were living artists, chiefly landscape painters, whose work was comparable with that of the Old Masters. To present drawings to Oxford was one thing; to persuade Oxford of their importance quite another – the University authorities did not even bother to thank, let alone reward, J.C. Robinson, the author of the superb catalogue of its Michelangelo and Raphael drawings (published in 1870).

4
Evening; cloud on Mount Rigi, seen from Zug,
sketch by Turner for his own pleasure
21.8 × 26.7 cm

Ruskin collected over 300 of Turner's watercolour drawings and gave many of them to Oxford, including, in 1861, the incomparable Loire series. This drawing made by Turner from the window of his inn, *La Cygne*, is an example of the sketches that lie behind his Swiss watercolours of the early 1840s which Ruskin regarded as among his greatest works. The drawing was no. 300 in the Educational Series. It is no. 86 in the *catalogue raisonné* of Turner drawings in the Ashmolean Museum included in *Ruskin and Turner* by Luke Herrmann (London 1968).

5
Morning in spring, with north-east wind, at Vevay
17.5 × 26.4 cm

This drawing in watercolour and body colour over some faint pencil lines on pale grey paper was probably made during Ruskin's Swiss tour of 1849 which produced an exceptional series of studies of Alpine scenery inspired by the example, but in no sense imitations, of Turner. Ruskin was at Vevay in May and early June of that year. Placed in the section devoted 'Rocks, Water and Clouds' in his Educational Series (as no. 298 (2)), it was probably originally made in connection with the studies of clouds which Ruskin eventually published in the third volume of *Modern Painters*.

6
Aiguilles near Chamouni
20.3 × 27 cm (detail in colour)

This is one of about fifty detailed drawings which
resulted from a bout of particularly intensive investi-
gations by Ruskin of mountain structure at Chamouni in
June and July 1849 – 'He noted all the angles of the
Aiguilles, observed every fleeting effect of cloud,
examined the rocks, collected the minerals, gathered the
flowers, and weighed the sand in the streams'. The
results appeared chiefly in *Modern Painters*, Volume IV,
of 1856 with its chapters on the 'Materials of Mountains',
the 'Sculpture of Mountains' and 'Resulting Forms' (of
which the first are Aiguilles). The way that the nervous
needle-sharp detail of the crags which interest him is
contrasted with the vaguely indicated shapes elsewhere
is typical of Ruskin's drawing procedure. This is one of a
small group of drawings by Ruskin presented by Miss
Mary Tyrwhitt in 1945.

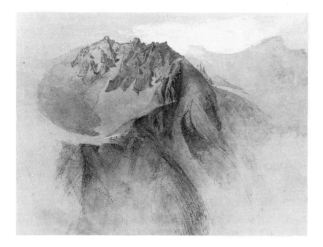

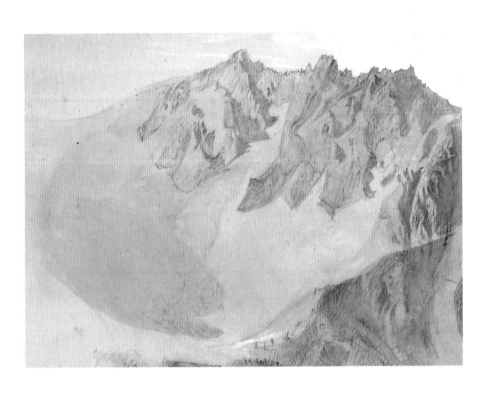

7 a, b
Studies of dawn (the first scarlet in the clouds, white clouds and purple clouds)
13.8 × 19 cm
15.4 × 22.3 cm

These studies in watercolour and body colour over faint pencil lines on blue and blue-grey paper were included by Ruskin in his Educational Series (as nos. 3 and 5) as simply and rapidly executed records of the dawn sky of a kind which he commended his students to make as a daily exercise which would 'calm and purify' their thoughts. Studies of this kind by Ruskin are very hard to date. They illustrate perfectly his conception of drawing as both a scientific record and an act of worship which had nothing to do with 'picture-making'.

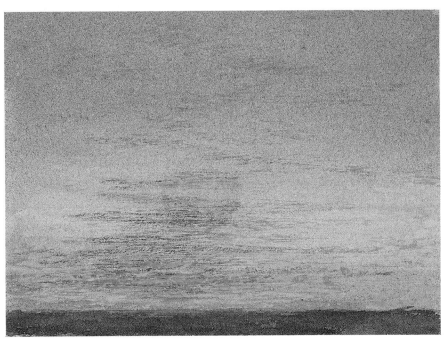

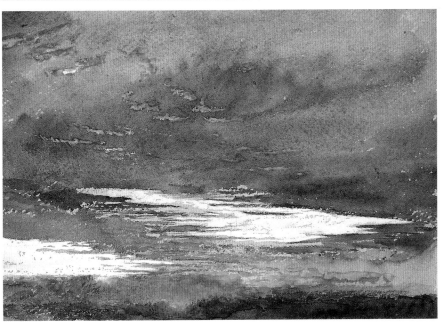

8
Study of trees (from Turner)
42.7 × 32.3 cm

This undated study with its precise miniature pen work in mauve ink with wash over bold swirling pencil lines is made from 'part of the group of Scotch Firs on the left of Turner's great picture *Crossing the Brook,* to show its complexities of light and shade'. *Crossing the Brook,* exhibited at the Royal Academy in 1815, now in the Tate Gallery, was admired by Ruskin in *Modern Painters.* 'The stems . . . especially the fainter ones entangled behind the dark tree' were 'above all praise for grace and truth'. Including it in the Rudimentary Series of his collection (eventually as no. 296), Ruskin hoped that the general students would imitate this example of studying the light and shade of foliage in a neutral tone before trusting themselves to green. They would be rewarded for their self-denial by an enhanced pleasure in winter scenery.

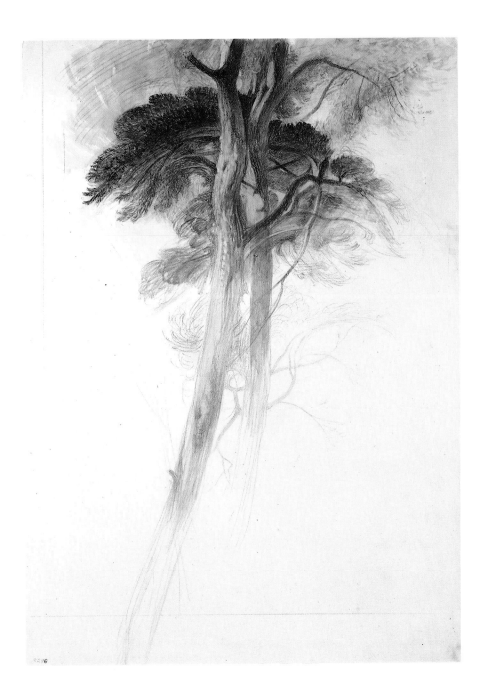

9
Stone pines at Sestri, Gulf of Genoa
44 × 33.5 cm

This drawing made by Ruskin on 30 April 1845, his second day at Sestri (on the first tour he made on the continent without his parents), is in a similar medium (pencil and pen with washes and white body colour) and on the same sort of coloured paper that he had favoured in his earlier finished views of town scenery (nos. 1–3 here), and like these drawings this probably represents a day's work. But, inspired by Harding and Turner, there is far more freedom and variety in touch and a bold disregard for the proprieties of composition. Significantly, indeed, Ruskin mounted the drawing so that much of the image was masked, which made it still less conventional in presentation. It was included in the Rudimentary Series of his collection (as no. 295) as an example of the 'utmost possible speed consistent with care' in drawing from nature, but also in the Educational Series (as no. 22) as a type of tree both strong and gracious which, growing on promontories, was believed sacred to Poseidon. Ruskin's sense of nature as holy, originally exclusively Christian in reference, involved, by the 1870s, sympathy for the religious attitudes of the ancient Greeks.

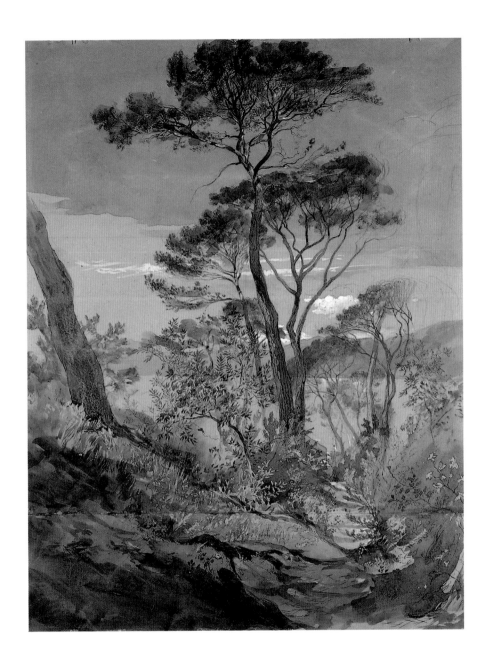

31

3
Pre-Raphaelite and scientific truth

Many of Ruskin's observations in the five volumes of *Modern Painters,* published between 1843 and 1860, on trees and rocks and clouds shift from art criticism to natural history and his drawings of gneiss boulders or of olive leaves were informed by an intense concern for what was distinctive about the type of rock or leaf depicted, and for the function of the leaf and history of the rock. Ruskin was in fact interested in minerals before he was interested in watercolours and his earliest published writing was of a scientific kind. He was also passionately averse to the segregation of science as a distinct discipline. Hostile to many modern tendencies, lecturing against Darwinism and resigning his Chair as Slade Professor because of the sanction given by the University of Oxford to vivisection, Ruskin nevertheless welcomed the modern theory of glaciers and was involved in the building of the Oxford Museum for which he designed appropriate ornaments (nos. 30 and 31 here). The collection he later gave to the University Galleries included plates from such volumes as Mrs Loudon's *Ornamental Bulbous Plants* and le Vaillant's *Histoire Naturelle des Oiseaux de Paradis* as well as many very careful geological, botanical and ornithological studies of his own, some of which are reproduced here. These latter certainly count among the most beautiful of his drawings.

It is noteworthy that Ruskin who had so much feeling for the 'life' even of inanimate things like boulders and for the distinctive personality of an eagle's head (which he described with Dickensian vividness) had little ability when drawing human beings – something which cannot entirely be

explained by the absence of a special kind of artistic training.

Ruskin was attracted by meticulous painting after nature at an early date. In his autobiographical essay *Praeterita* he recalled how the walls of the breakfast room of his parents' South London house were 'mostly covered with lakes by Turner and doves by Hunt'. The still-life watercolours by William Henry Hunt (not to be confused with the Pre-Raphaelite William Holman Hunt) were highly popular in the 1840s and their miniature precision was praised by Ruskin in *Modern Painters*. Ruskin was also keenly interested in daguerrotype photography in which blades of grass and leaves of ivy were reproduced with a sharp clarity that bewildered – and stimulated – the eye.

The Pre-Raphaelite Brotherhood, formed in 1849, were as impressed by Ruskin's call for uncompromising precision in recording nature as they were by his ardent advocacy of the merits of Italian medieval fresco painting. Ruskin took up their cause in the early 1850s and worked for a while very closely with Millais (and later with Brett).

10
Yellow snailshell and grapes by William Henry Hunt
13.8 × 9.3 cm

This still life watercolour drawing in Hunt's typical stippled manner was cut by Ruskin out of a larger work (along the left) although the drawing has been retouched to conceal this. Ruskin's preparedness to cut up works of art – including illuminated manuscripts – seems astonishing in light of his attacks on the treatment of medieval architecture. He included this drawing as no. 40 (and eventually as no. 192) of his Educational Series as an aid to the study of zoology as well as to the art of drawing. He praised the honesty and modesty of Hunt's work but hinted at its limitations when he described its 'general look of greengrocery and character of rural simplicity'.

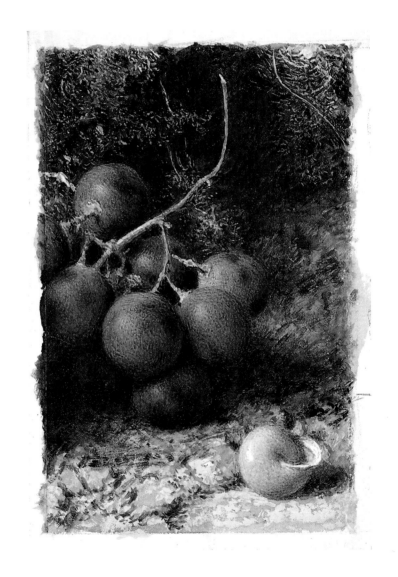

11
Study of gneiss rock, Glenfinlas
47.7 × 32.7 cm

This drawing is in pen and ink with wash, but some highlights in the vegetation, indeed some whole plants, are added in chinese-white, and the highlights on the broken water are scratched out. It was made at Glenfinlas in Scotland in the summer of 1853 when Ruskin and Millais were working together – and Millais was also falling in love with Ruskin's wife. It was probably begun on 19 July when Ruskin noted that he drew but that Millais had a headache. Millais's famous portrait of Ruskin belongs to the same period and was painted near the same spot. The rejection of spatial context, the absence of conventional compositional devices, the densely crowded and sharp detail, would seem to have been suggested to Ruskin by daguerrotype photography. The drawing was famous in Ruskin's lifetime and he authorised the sale of photographic prints of it. It was no. 89 in the Reference Series of his collection.

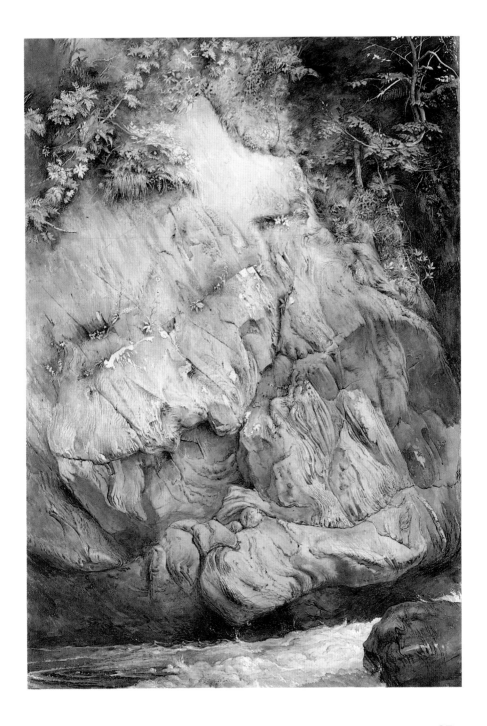

37

12
Oakspray in winter seen in front
21.9 × 26.6 cm

This drawing in mauve watercolour and white body colour on blue paper (a typical combination) was engraved with the poetic title 'The Dryad's Waywardness' by R.P. Cuff as Plate 59 of the last volume of *Modern Painters* (published in June 1860) and seems to have been drawn by Ruskin to illustrate his argument there concerning the curvature of boughs and Turner's understanding of this. Placing the drawing in the Elementary Series (no. 266) and Rudimentary Series (no. 282) Ruskin emphasized that the nearest branches of trees are generally seen foreshortened and that 'in a branch, as in a boat' such views were the most attractive. The inscription 'By itself' is probably a note by Ruskin that the drawing was not to be mounted with another of the same branch seen from the side.

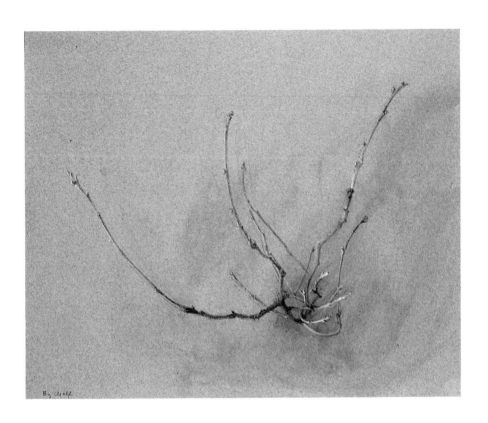

13
Spray of olive
34.6 × 26.5 cm

Executed with a brush in body colour and pencil on a
paper with a blue wash, this drawing must be the
replacement, promised in Ruskin's catalogue, for the
pen and pencil study of a dry spray which was originally
no. 10 in the Educational Series of his collection. Ruskin
hoped that it would be compared with a drawing
made by his assistant Arthur Burgess which was an
enlargement of the 'wreath of olive round the head of
Jupiter on a copper coin of Syracuse'. The intention was
for the student 'to feel the manner in which the Greeks
adapt natural vegetable form to ornamental purpose;
and secondly, that he may recognize the undulating
languor of the Greek lines as opposed to the spring or
rigidity in the natural one'. Burgess's drawing was
originally made as an illustration for the series of
lectures entitled *Aratra Pentelici* which Ruskin delivered
in Oxford in the winter of 1870 much of which
concerned Greek coins.

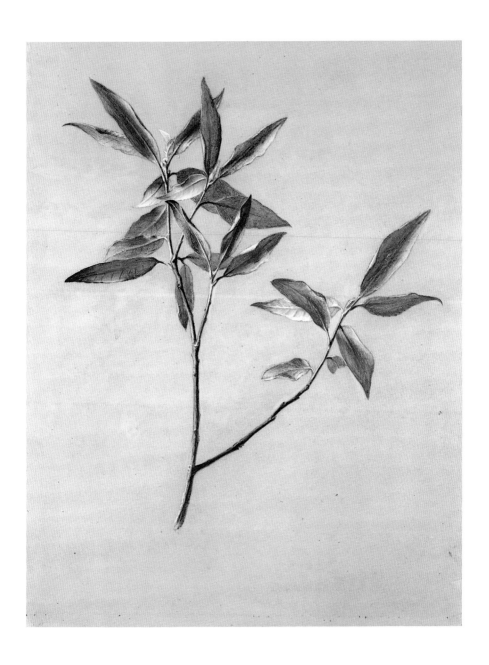

14
Study of kingfisher, with dominant reference to colour
25.8 × 21.8 cm

This drawing in watercolour and body colour over faint pencil indications was probably made in 1870 or 1871 in connection with Ruskin's Oxford lectures and was placed by Ruskin in the Rudimentary Series of his collection (as no. 201) in the cabinet devoted to 'Exercises in Colour with Shade on Patterns of Plumage and Scale'.

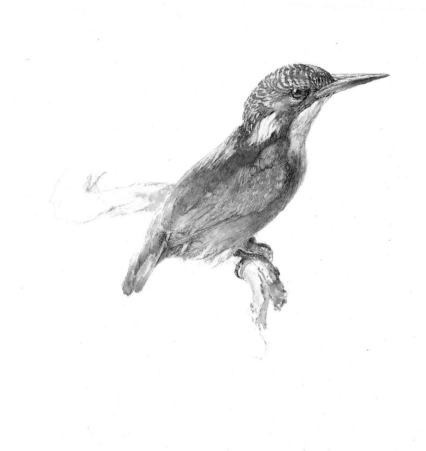

15
Feathers of the kingfisher's wing and head, enlarged,
and a group of the wing feathers, real size
37.5 × 25 cm

Companion with no. 14 in the Rudimentary Series (as no. 204).

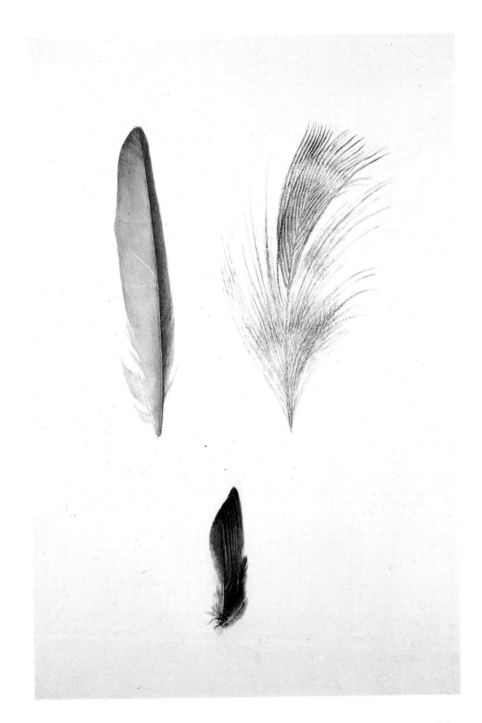

16
Study of a velvet crab
31.4 × 24.5 cm

An undated drawing, perhaps made in connection with Oxford teaching, in watercolour and body colour over pencil on blue-grey paper, placed by Ruskin in the Educational Series of his collection (as no. 199) in the cabinet devoted to Elementary Zoology. Ruskin was as sensitive to the mixed colouring of shells as he was to that of marble.

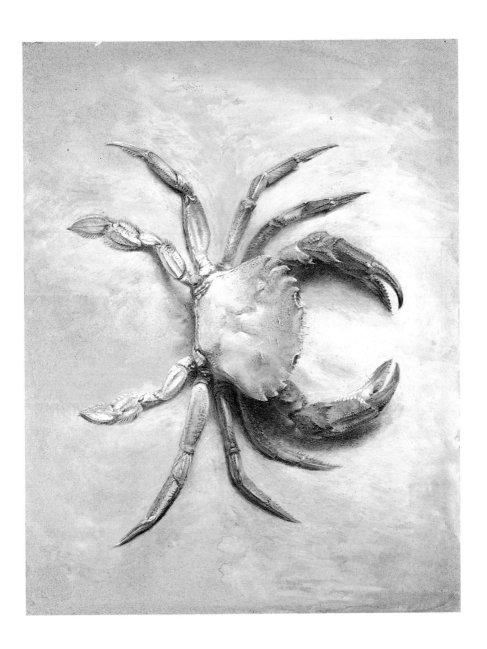

17
Owl in Mantegna's fresco of the martyrdom of
St James
49.5 × 34.4 cm

This 'wonderful study', as Ruskin rightly described it,
was made as a lecture illustration for Ruskin by Arthur
Burgess, in black chalk with white heightening, from a
photograph of the fresco, enlarging the detail there
to its actual size to give an idea from a distance of 'a
great draughtsman's manner of using the brush'.
Ruskin also commended it as 'an admirable exercise in
chalk-drawing' and wanted to have it engraved. The
photograph itself was in Ruskin's collection (Standard
Series no. 35). This drawing was placed in the
Rudimentary Series (as no. 46) next to an old wood-cut
of an owl and a sketch of a lion from nature. For Ruskin
the study of animals, vegetables and minerals was never
far removed from the study of how great artists had
rendered them. The whole sheet is reproduced here but
lines on the drawing itself indicate that much of it was
intended to be masked by the mount whose original
aperture was 40.5 × 26.7 cm.

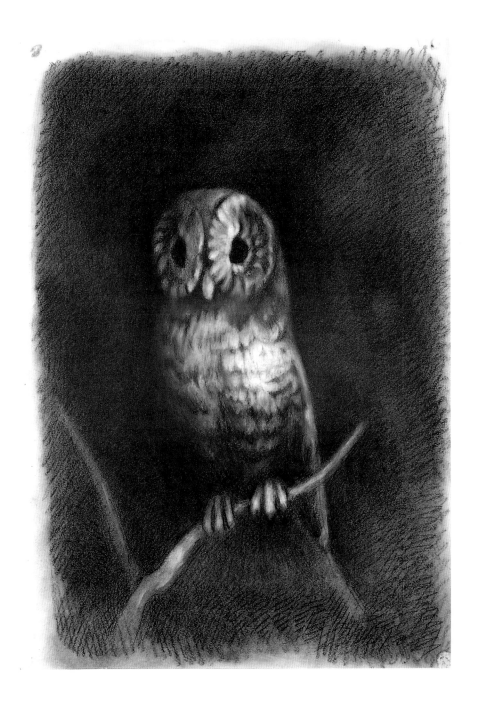

18 a, b
Studies of a swallow's wing and a dead dove
13.5 × 25.1 cm
21.2 × 30.1 cm

Watercolour drawings included by Ruskin in the section 'Birds chosen for Exercises in Plumage-Pattern' of his Rudimentary Series (as no. 181). It is typical that Ruskin mentions that the drawing of the dove was not made from a living specimen, as he would certainly have preferred. Ruskin also owned several examples of Turner's exceptional watercolours of dead game birds made at Farnley Hall in Yorkshire including one – of a pheasant – which he presented to the Ashmolean Museum.

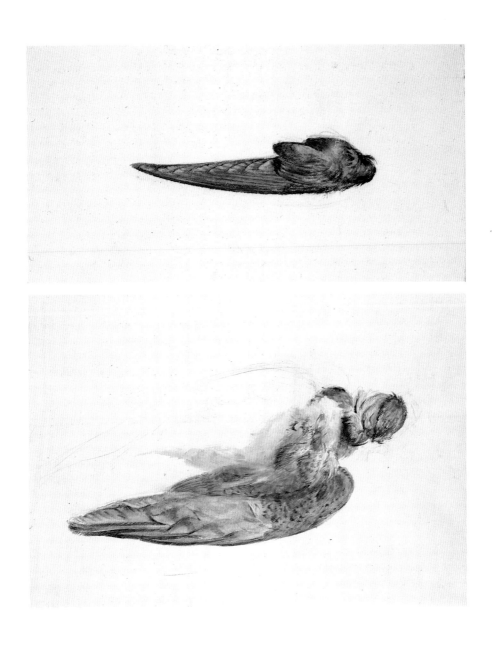

19 a, b
Eagle's head (common golden) from life
8.8 × 14.9 cm
16.3 × 19.5 cm

These two superb drawings were made in watercolour with white body colour over pencil in the zoological gardens on 9 and 11 September 1870; the lower of the two was regarded by Ruskin as 'a failure in the feathers but useful'. These were used, and probably made, by Ruskin to illustrate the eighth of his Oxford lectures in the series *The Eagle's Nest* delivered on 2 March 1872 where he attacked the assumptions of anatomists, pointing out that neither the brow nor the lips of an eagle were apparent in its skull, yet the projection of the former was essential to protect the keen downward looking eye from the sun, and the 'fleshy and ringent mouth, bluish pink, with a perpetual grin upon it' was also an essential feature. He placed the drawings in the Educational Series (as no. 165) in a section devoted to Elementary Zoology.

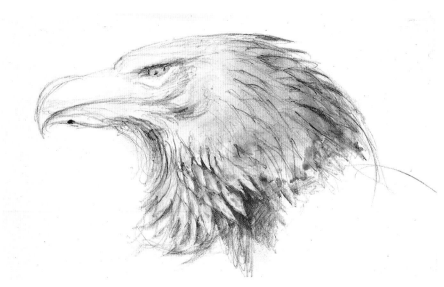

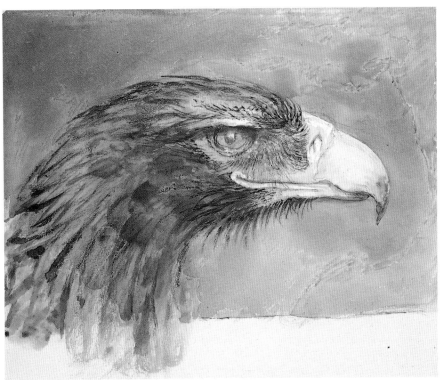

4
Architecture, colour and ornament

Many of Ruskin's earliest drawings were of gothic architecture – it had been the preferred subject of Samuel Prout whose drawings and lithographs were an early source of inspiration to him and which he continued to revere. 'Proutism', as he called it, disposed him to admire the French Flamboyant (found for example at Abbeville – no. 21) where the mass is dissolved into ornamental line and naturalistic ornament. Ruskin always defended this late type of Gothic although contemporary enthusiasts for gothic architecture condemned it as decadent, and his arguments in favour of gothic architecture of all kinds often emphasized the organic character of the forms. The life of a building for him, however, also consisted in its history. He argued that wear and weathering were essential to their character. He was violently opposed to restoration which then generally involved recutting and reproduction, and he both made and commissioned drawings to record buildings (in Italy especially) before they were treated in this way. His attitude to restoration was enormously influential and is now widely shared.

Ruskin's appreciation of the Gothic was not surprising, in view of his interest in the picturesque. Nor is it surprising that he adopted, in *The Seven Lamps* of 1849 and then in *The Stones of Venice,* the belief that medieval architecture was the only truly sacred and honest style of building. This view had already been expounded very forcefully for over a decade in the Catholic polemics of Pugin and in the High Anglican *Ecclesiologist.* What was far more original was Ruskin's praise for what had generally been dismissed as barbaric elements in Italian

medieval architecture and sculpture and his concept of structural polychromy – colour built into, rather than added to, buildings, an idea also taken up (independently it seems) by William Butterfield and George Edmund Street, and to be seen in such notable buildings in Oxford as Balliol College Chapel and the Church of St Philip and St James. Ruskin's appreciation of such qualities in architecture dates from his Italian tour of 1845; there is no hint of it in the drawings of 1840 and 1841 (nos. 1–3 in this book).

The tour of 1845 was made without his parents after the success of the first volume of *Modern Painters*. The chief purpose of his visit was to equip himself to extend the pontifications of his first volume to cover all periods of painting, which meant studying the earlier schools of Italian art (these had in fact been a fashionable subject for some years). But the tour produced his first truly vigorous drawings of trees (such as no. 9) and his first diligent and powerful studies of architecture (such as nos. 24 and 25).

His watercolour studies of the mass, the colour and the ornament of ancient Italian architecture made later in his life are among the most astonishing of all his works. By comparison, his attempt to introduce such qualities into a modern building in Oxford seem disappointingly tentative. He formed no relationship with practising architects comparable with those he had with Turner or Millais.

20
Market-place (Place de l'Amiral Courbet), Abbeville
36 × 51.7 cm

This highly finished and detailed – but not quite complete – pencil drawing is exceptional among Ruskin's mature work. It was begun on 10 September 1868 and he worked on it intermittently for over a month, partly, it seems, from his diary, for therapeutic reasons. The choice of subject is reminiscent of his drawings of 1841 and Ruskin himself significantly placed it in his Reference Series (as no. 61) next to 'The Market-Place, Verona' (no. 3 in this book).

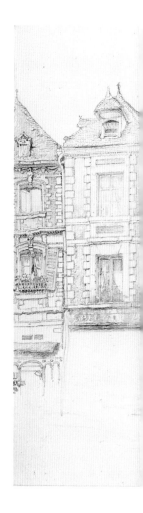

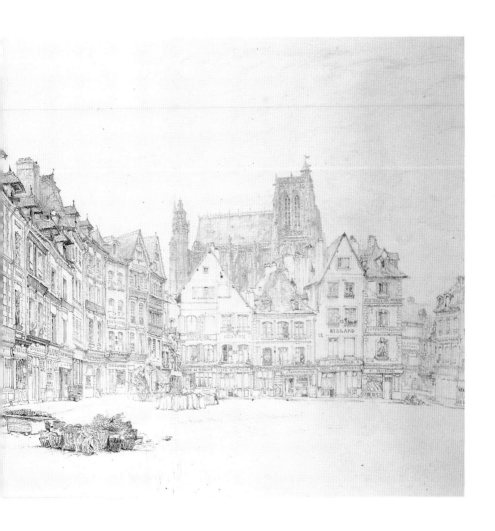

21
The south porch of St Vulfran, Abbeville
47.3 × 31 cm

This study in pencil and wash of part of the church which features in the distance of no. 20 – the 'last of its race', Ruskin regarded it – was executed during the same period, but is far more typical of Ruskin's drawings. Ruskin attached little value to the compositional unity of elevation, or to the coherence of plan, in gothic buildings – he appreciated them no less if they were fragmentary – and his drawings reflect this. His fierce concentration on some parts seems to leave him too exhausted to consider the remainder – exactly as when he studies mountains or rocks (nos. 6 and 22). Together with no. 20 and many other drawings this was exhibited as an illustration to Ruskin's lecture 'The Flamboyant Architecture of the Valley of the Somme' delivered at the Royal Institution on 29 January 1869. It was later placed in the Reference Series (as no. 95) of his collection.

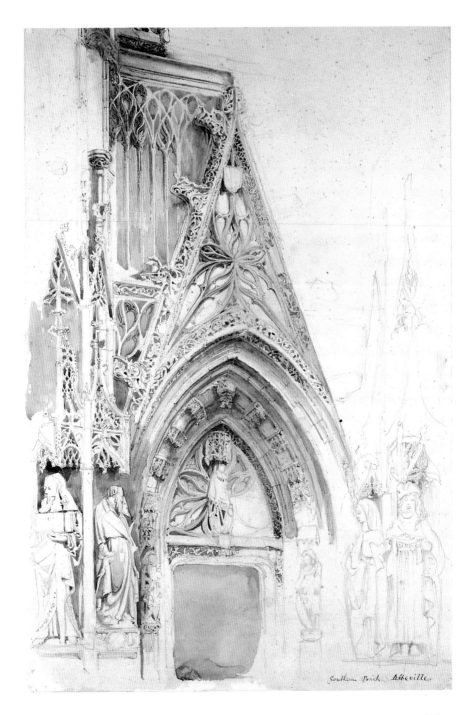

Southern Porch, Abbeville.

59

22
Moss and wild strawberry
54 × 38 cm

This beautiful drawing in pencil with some faint heightening in white chalk on blue-grey paper included by Ruskin in the Reference Series of his collection (as no. 90) was dated by his editors as of 'about 1880' but this may well be a rare misprint or mistake. Another drawing of a strawberry plant entitled 'The rose of Demeter in the cleft of her rocks' in the Ashmolean Museum is dated June 1873 and was made at Brantwood, Ruskin's home in the Lake District. Although a study of rock and vegetation the drawing is irresistibly reminiscent of Ruskin's writing on the proper relation of ornament to architectural form – architecture should emulate the massive strength of the rocks from which its stones were hewn but also possess the linear vitality of vegetation and exquisite ornament. He was indeed sympathetic to old buildings having real plants growing on them (see no. 25 here) and even commended gothic architecture for the spaces it provided for nests.

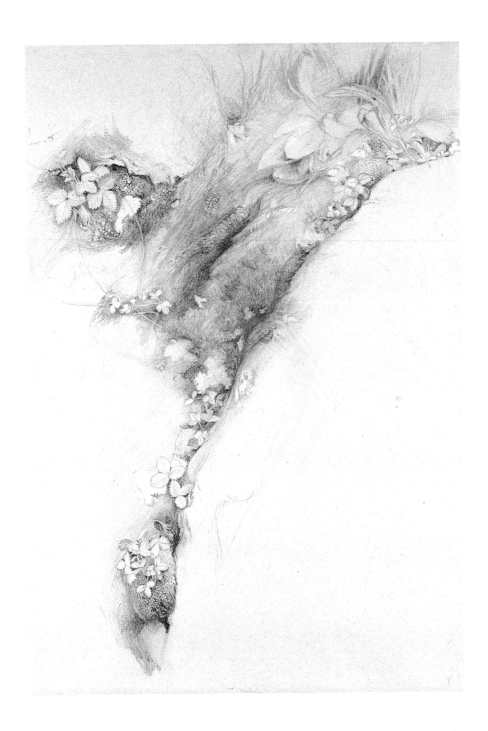

23
Type of form of shield, from tomb of Eleanor of
Castile (in Westminster Abbey)
40.5 × 33 cm

Ruskin had become interested in heraldry as part of his
study of medieval chivalry which arose out of his
enquiry into the social circumstances which permitted
the flowering of gothic architecture and his dismay at
the materialism of modern Europe. Its symbolism
appealed to him, but so did the opportunity it provided
to discuss basic principles of design. This drawing, in
pencil with some wash, was one of a number made in
the winter of 1871–2 to illustrate an Oxford lecture in
the series *The Eagle's Nest* entitled *The Heraldic
Ordinaries* delivered on 9 March 1872; hence its large
size. He placed the drawing in the Rudimentary Series
of his collection as no. 11 – a cast from the tomb was also
in the collection. Even here Ruskin emphasizes not only
what the shield is carved out of, but its age, a reminder
that it was a relic of the past to be preserved (but not
restored) for posterity. The arms are those of the County
of Ponthieu.

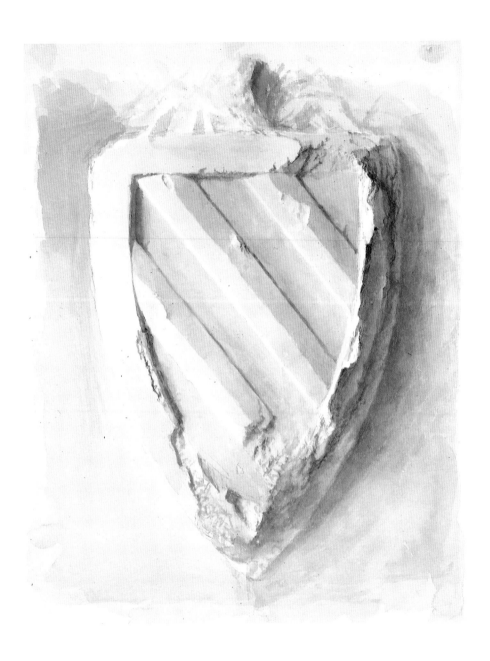

24
Part of the façade of San Michele at Lucca
33 × 23.3 cm

This very careful study in watercolour, with white body colour, over pencil, partly ruled, reinforced with pen and ink on green paper, was signed by Ruskin in 1845 and was probably made on 6 May in 1845. He wrote to his father on that day after dinner (served at 2.00) 'I am again ready to set to work, and then I sit in the open warm afternoon air, drawing the rich ornaments on the façade of St Michele. It is white marble, *inlaid* with figures cut an inch deep in green porphyry, and framed with carved, rich, hollow marble tracery. I have been up all over it and on the roof to examine it in detail. Such marvellous variety and invention in the ornaments, and strange character. Hunting is the principal subject – little Nimrods with short legs and long lances – blowing tremendous trumpets – and with dogs which appear running up and down the round arches like flies, head uppermost . . . After working at this till half past five or so, I give up for the day . . . ' Ruskin wrote about this extraordinary building in *The Seven Lamps* and then again in the *Stones of Venice* in the first volume of which he included an engraving after this drawing by J.C. Armytage dramatically cropped within the dots marked on the drawing with the letter P. He included it in the Educational Series (eventually as no. 83) of his collection, noting that restoration and rebuilding (which took place in 1862) had destroyed what he had recorded. There are other less meticulous studies of the same building in the collection.

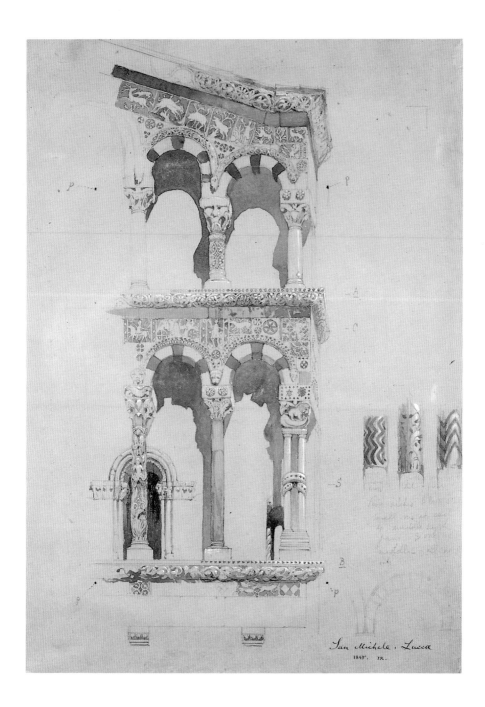

San Michele · Lucca
1845. JR.

65

25
Study of the marble inlaying on the front of Casa Loredan, Venice
34.2 × 29.6 cm

This drawing, like no. 24 in a mixture of techniques on green paper, and also made in 1845, shows how seriously Ruskin was using his gifts as a draughtsman 'to get accurate knowledge of some point in the building', rather than to make an attractive picture. He explained in his catalogue of the Rudimentary Series of his collection (where this was no. 22 and chiefly intended to demonstrate the 'proper treatment of heraldry in sculpture') that, 'if you will look with a magnifying-glass at the bit of foliage in the front of the casque and at the door and window of the castle that surmounts it, you will see that the accuracy with which these were drawn was wholly incompatible with picturesque effect unless I had been John Lewis, instead of John Ruskin, and given my life to such work. But the pieces of yellow leafage above are freely and rightly painted, first with chinese-white and then glazed'. For similar miniature work in chinese-white on foliage see no. 11.

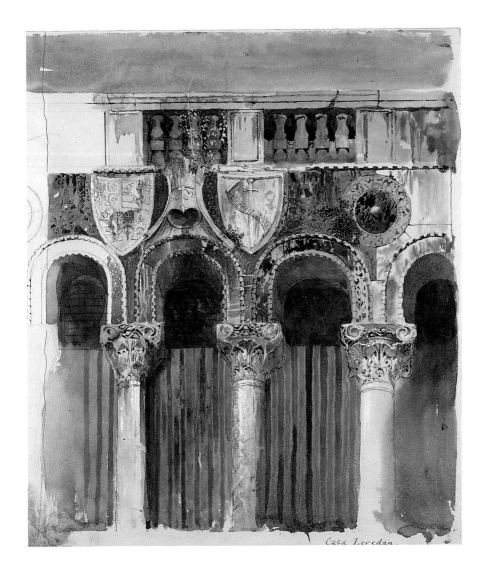

Casa Loredan.

26
Exterior of Ducal Palace, Venice
36.25 × 50.3 cm

Ruskin used this drawing in pen, wash and pencil for an exhibition illustrating his lecture on Verona and its architecture delivered at the Royal Institution in 1870 where he noted that it was 'sketched in 1852, by measurement, with extreme care; and showing the sharp window traceries, which are rarely seen in photographs'. Some pencil annotations on the length of the intervals in the balustrade can be discerned on the left, reminding us that Ruskin climbed up the buildings in Venice as energetically as he did the mountains in Switzerland. Ruskin was a keen architectural photographer and the character of his drawings was stimulated by the deficiencies of photographs as well as by their qualities. This view is made from the water, where photography was at that date impossible, long exposures requiring steady tripods. Ruskin was in Venice a great deal between the late summer of 1851 and the early summer of 1852 working on *The Stones of Venice*. When placing the drawing in the Reference Series (as no. 67) of his collection he dated it 1845 – an understandable slip because that was the year in which his serious study of Venetian polychrome architecture commenced (as can be seen from no. 25).

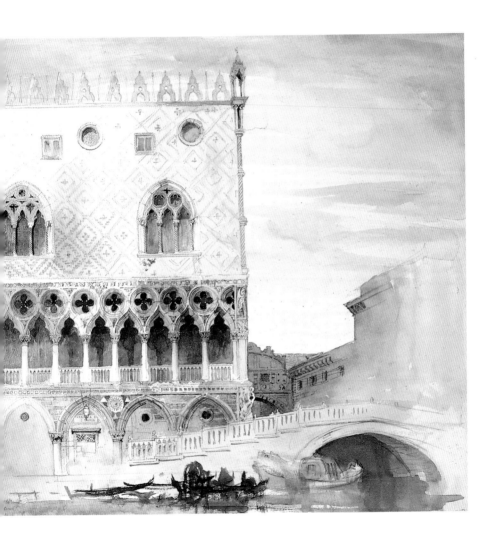

27
Marbles at Verona
51.8 × 22 cm (image)

This study in watercolour and body colour over faint pencil lines, some of them ruled orthogonals, is of the lower panels and base mouldings of a pilaster of the Church of Santa Anastasia, and was made by Ruskin between 9 and 15 June 1869 and exhibited in the following year at his Verona lecture for which purpose it was probably made. It was added (as no. 68) to the Reference Series of his collection. The 'peach-blossom' marble of Verona, in fact a limestone with mottled pattern varying from pinky orange to cream, found in the mountains between Verona and Trent, was especially beloved by Ruskin. It enhances the staining, texture, and translucent glow of the neighbouring white marbles.

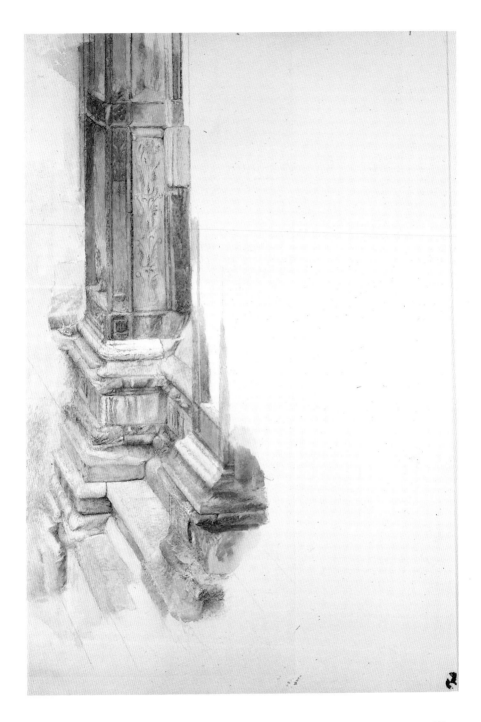

28
The Baptistery, Florence
52 × 34.5 cm

This large drawing in watercolour and body colour over
pencil, unusual for Ruskin in its completeness, and also
unusual for him in its interest in classic harmony of
form, represents one compartment of the south-west
façade of the Baptistery at Florence and is probably the
drawing to which he referred (and which he surely
employed as an illustration) in his lecture on Ghiberti in
Oxford in the winter of 1874. He described it as a work
he had executed two years before (presumably in May
or June 1872), adding that he 'never took more pains
with a drawing'. It was no. 120 in the Reference Series of
his collection.

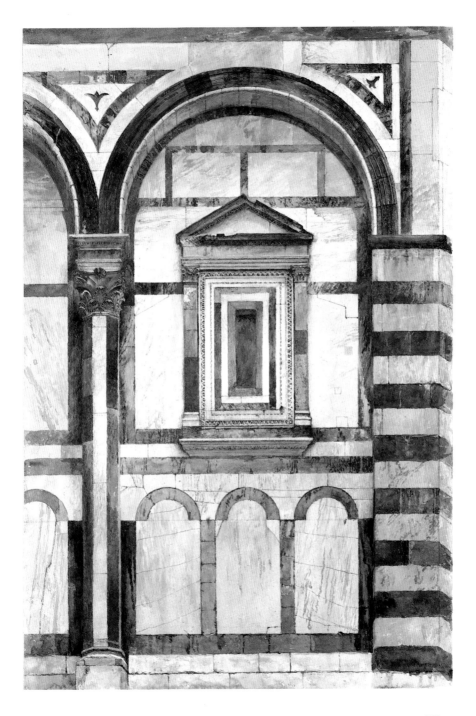

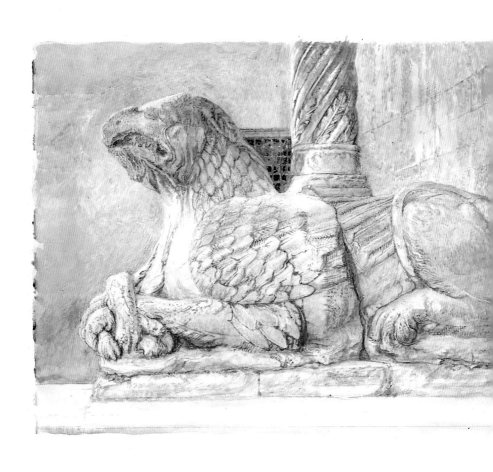

29

Gryphon bearing the north shaft of the entrance of the Duomo, Verona

22 × 35.7 cm

This drawing in watercolour and body colour over pencil was being made by Ruskin on 22 June 1869, when he wrote to his mother concerning it: 'I am painting him on the other side from that I engraved in *Modern Painters,* and the marble of him comes all into beautiful orange and grey, and I'm continually finding out new feathers and sinews in him that I did not know of'. In the third volume of *Modern Painters* Ruskin had discussed and illustrated this sculpture, ingeniously proposing that it showed how medieval artists were true to nature even when inventing composite beasts. This was displayed in the exhibition illustrating his Royal Institution lecture on Verona delivered 4 February 1870. He placed it in the Educational Series of his collections (as no. 82), confusingly in a case devoted to illustrations of Italian Gothic art, although it is a pre-Gothic, 'Lombardic', work. (Another fine drawing showing the whole porch is no. 81 in the Educational Series.) The drawing is a good example of how hard it is to keep Ruskin's varied interests within separate divisions. It is a study of architectural ornament, a study of another artist's zoology and mythology, and also a mineralogical study comparable with the drawing of the gneiss rock at Glenfinlas (no. 11).

30
Study for the Oxford Museum
26.4 × 36.8 cm

Through his friendship with Dr Henry Acland, Ruskin
was in 1855–9 able to advise upon and even to help
design aspects of the new University Museum devoted
to natural history, and the two drawings here (this and
no 31, both of them from a group bequeathed by Miss
Acland in 1931) are evidence of the extent of his
participation. The carving was based on both botanical
and zoological studies – one of the former can be seen
on the bottom right-hand corner of this sheet. What
was legitimate as formalisation and fantasy in adapting
such studies to ornamental purposes was a major
preoccupation of Ruskin's. In the carving carried out by
the Irish craftsman O'Shea in one of the double-arched
ground-floor windows we find capitals united by
interlaced foliage, projecting spurs of floral ornament
between the column shafts, and bases decorated with
intertwined reptiles, much as Ruskin projected in these
sketches.

31
Study for the Oxford Museum
36.7 × 25.9 cm

The windows depicted here were never executed but the ornament is very similar in its vitality to some that O'Shea did carve, especially for the first-storey windows. The colour in the building comes from British stones of the sort also displayed (as were botanical and zoological examples) within the Museum. These were intended as native equivalents to the dark green *verde di Prato* of the Florentine Baptistery and the pink marble of Verona (see nos. 27, 28 and 29); but nothing as vivid as the green in this drawing was employed. The carving in the building looks tentative, but it was never completed. Ruskin was no more successful in impressing himself upon the University Museum than he was at infiltrating his principles of artistic education into Oxford's teaching through the establishment of a school within the University Galleries. Something, however, remains.

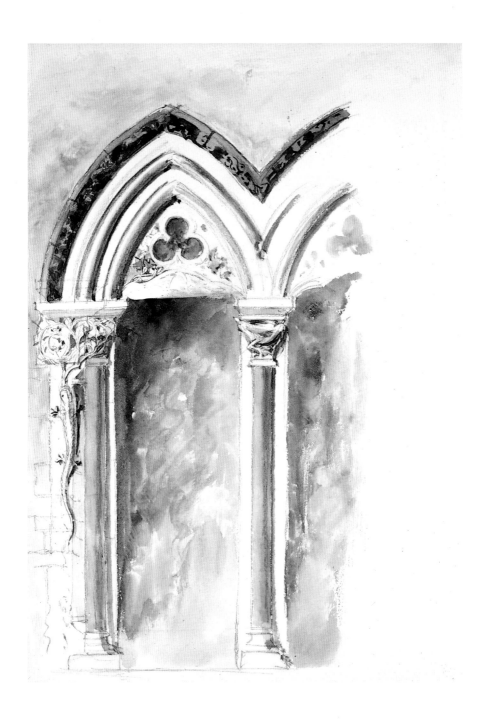